More Ancients of Assisi (Book II)

FROM THE BASILICA OF SAINT FRANCIS TO THE ROCCA MAGGIORE

LAINE CUNNINGHAM

More Ancients of Assisi (Book II)
From the Basilica of Saint Francis to the Rocca Maggiore

Published by Sun Dogs Creations
Changing the World One Book at a Time
Print ISBN: 9781946732477
Hardcover ISBN: 9781946732484

Cover Design by Angel Leya

Introduction

Assisi was the home of several saints, including Agnes of Assisi, Gabriel of Our Lady of Sorrows, Rufinus of Assisi, Vitalis of Assisi, Sylvester of Assisi, and St. Francis himself. The pink stones used to build many of the Franciscan buildings were quarried from Monte Subasio, the mountain on which the city was built.

Inside the walls of historical Assisi is the Basilica di San Francesco, which has been declared a UNESCO World Heritage Site. Nearby is Santa Maria Maggiore, which was built atop a temple dedicated to Apollo.

Since the residents of Assisi have continued to hold onto their traditional lifestyles, the town offers so much more. High atop a slope overlooking Assisi is the imposing Rocca Maggiore, an imperial fortress reconstructed by Cardinal Albornoz and expanded by Popes Pius II and Paul III.

Hidden beneath the streets is the Roman Domus of Propertius with its frescoed walls. Archaeologists have also preserved the Domus of Lararium, which sports a marble floor mosaic and a covered port with Pompeian decorations.

The photographs in *Ancients of Assisi I* and *Ancients of Assisi II* were taken at the Basilica di San Francesco, including the Basilica inferior and the Basilica superior; the Sacro Convento, a Franciscan friary; the Rocca Maggiore, a castle that is 800 years old; Santa Maria Maggiore; the Basilica of Santa Chiara, or Saint Clare; and the Roman Domus of Propertius and the Domus of Lararium, both of which are underground. Turn the page to stroll through the millenniums.

BEKONSCOT

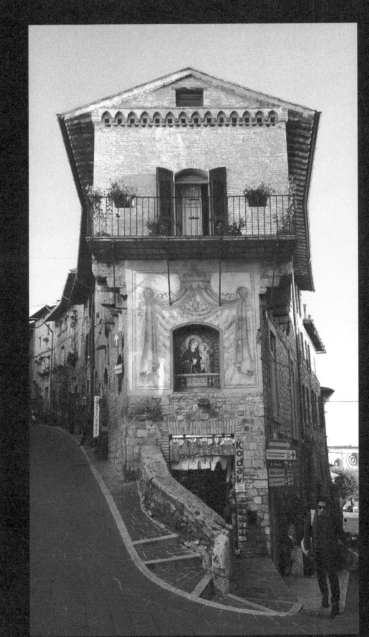

AT THE CORNER

ROCK FLOWERS

JOURNEY ON

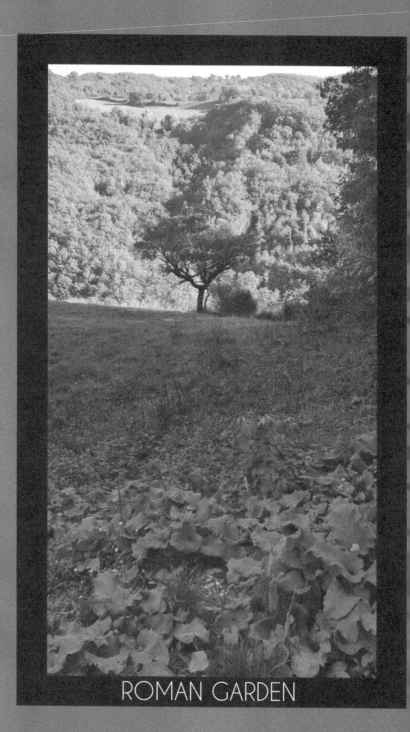

ROMAN GARDEN

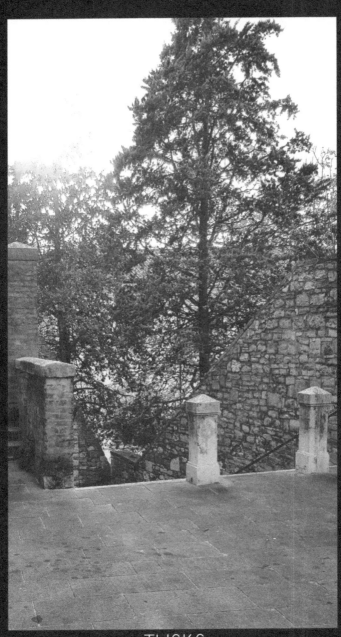

TUSKS

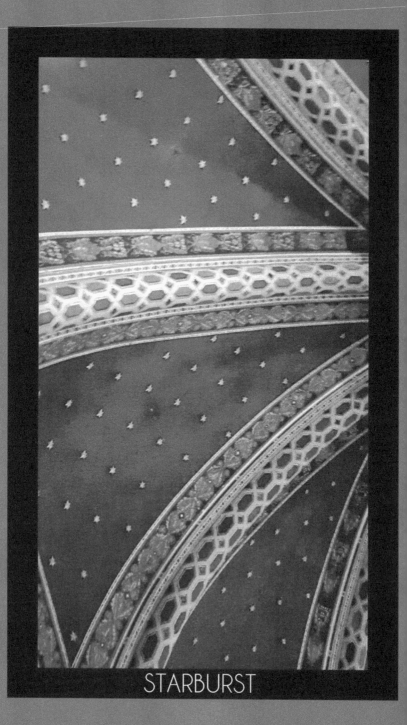

STARBURST

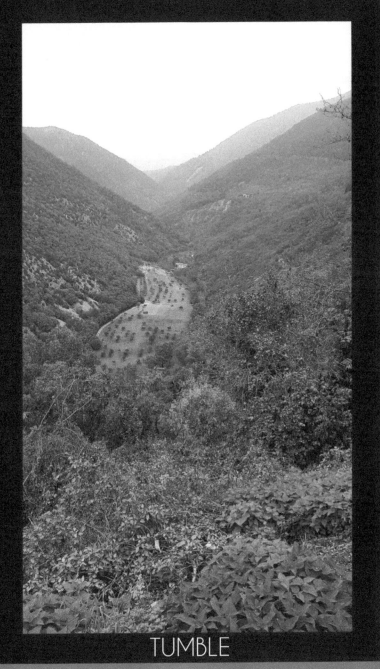

TUMBLE

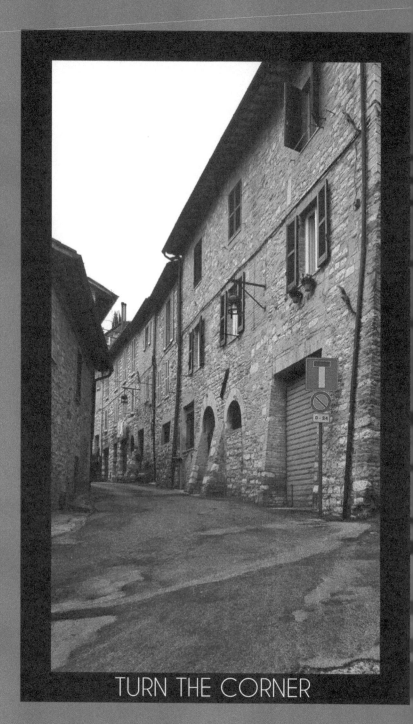

TURN THE CORNER

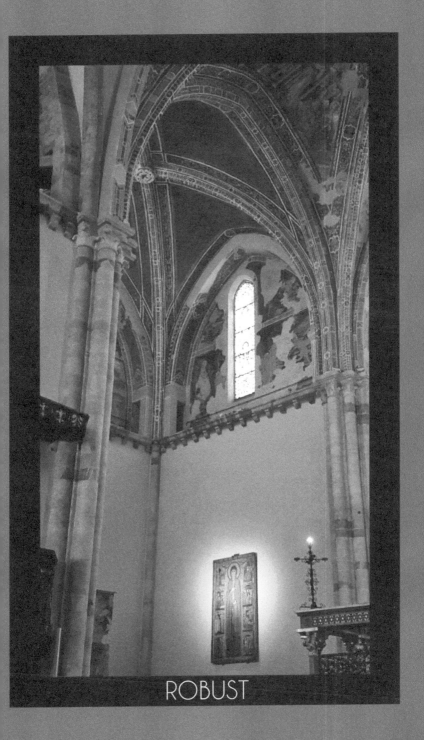

ROBUST

HIP LIPS

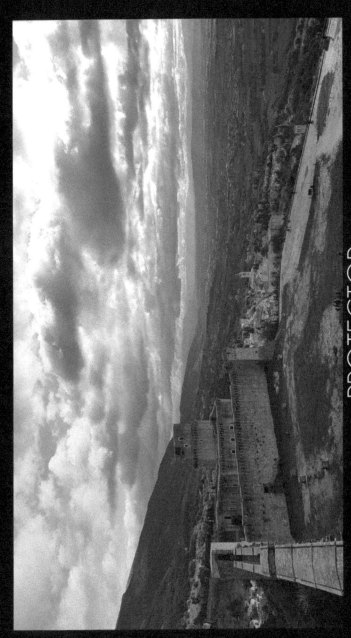

PROTECTOR

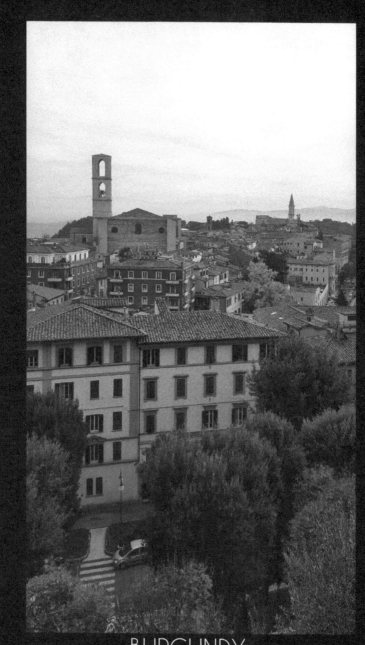

BURGUNDY

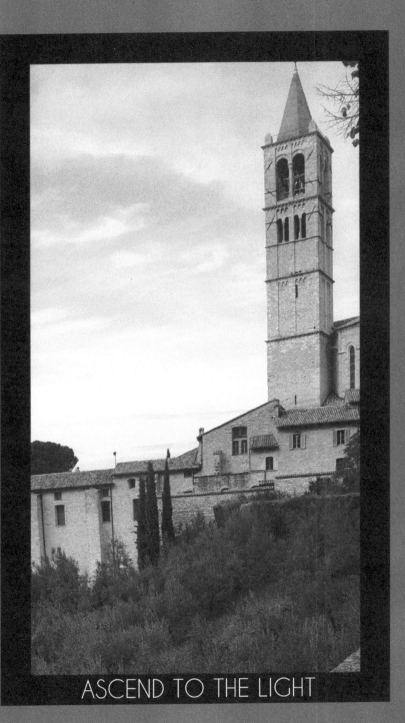

ASCEND TO THE LIGHT

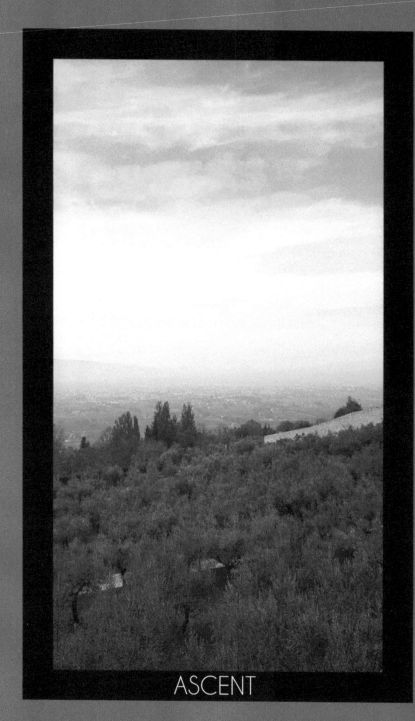

ASCENT

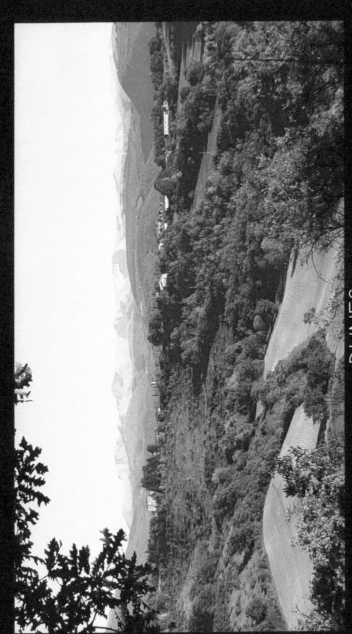

DUNES

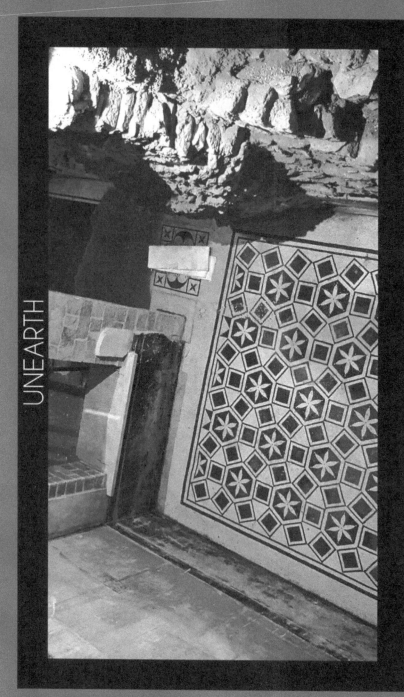

UNEARTH

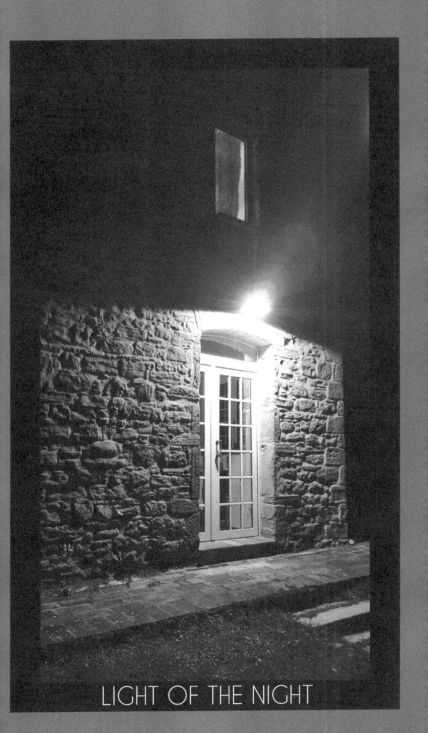

LIGHT OF THE NIGHT

ANCIENT DREAMWAY

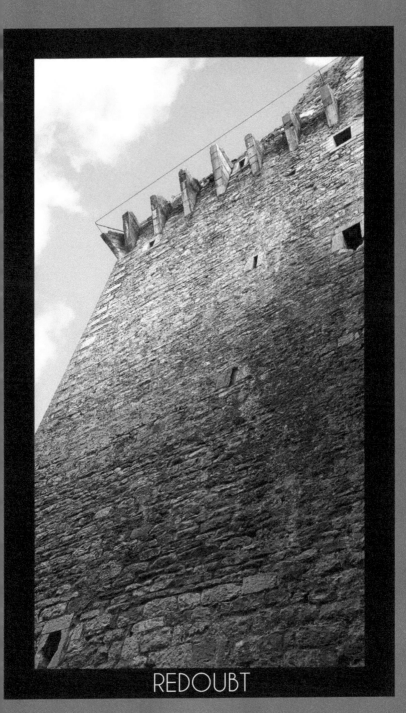

REDOUBT

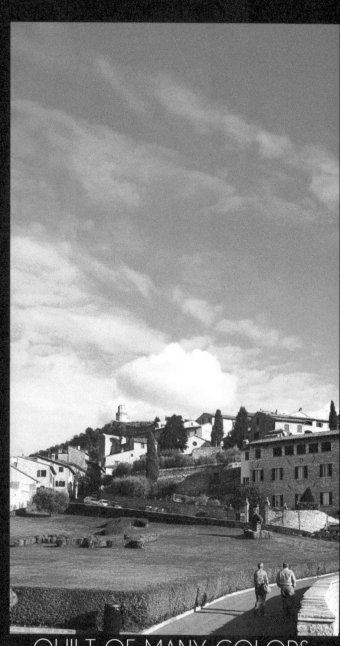

QUILT OF MANY COLORS

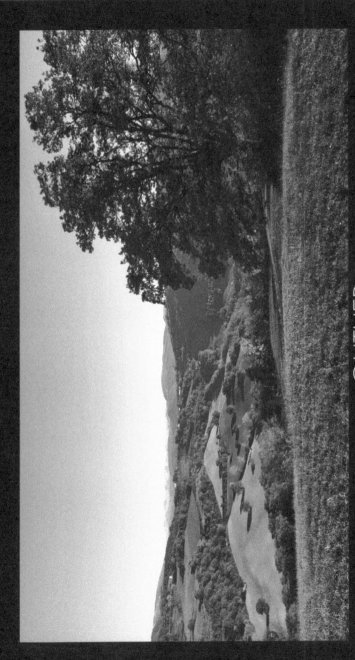

OUTLIER

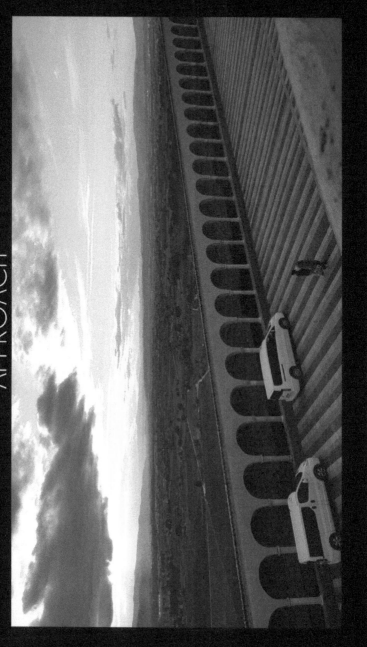

APPROACH

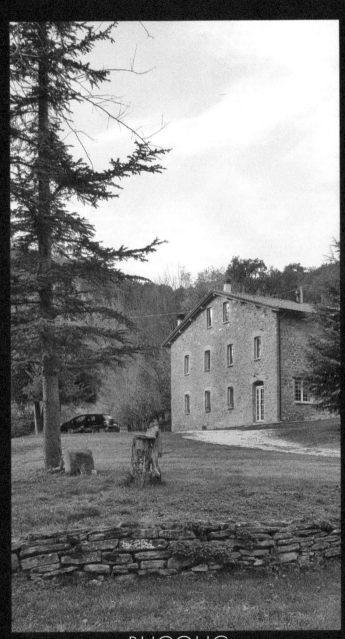

BUCOLIC

BABY FISTS

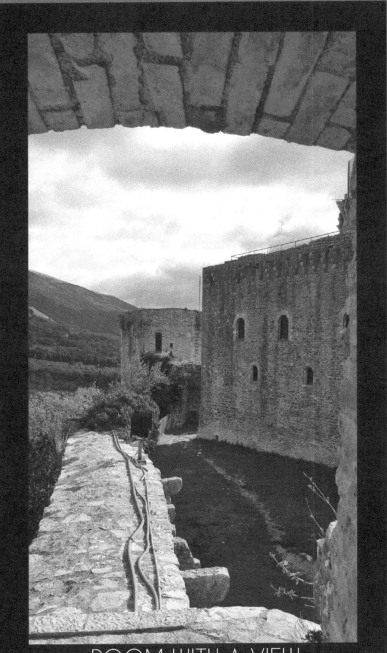

ROOM WITH A VIEW

WHAT'S FOR LUNCH?

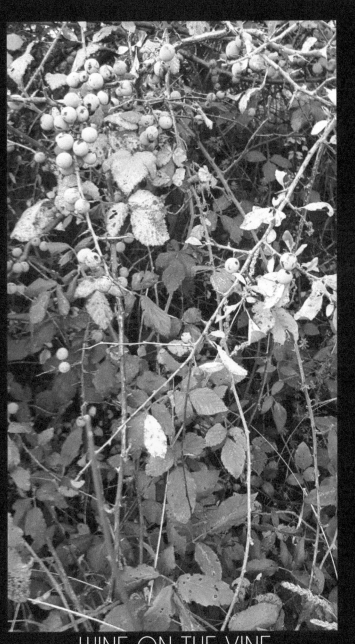

WINE ON THE VINE

NIGHT LIFE

NATURAL PORTRAIT

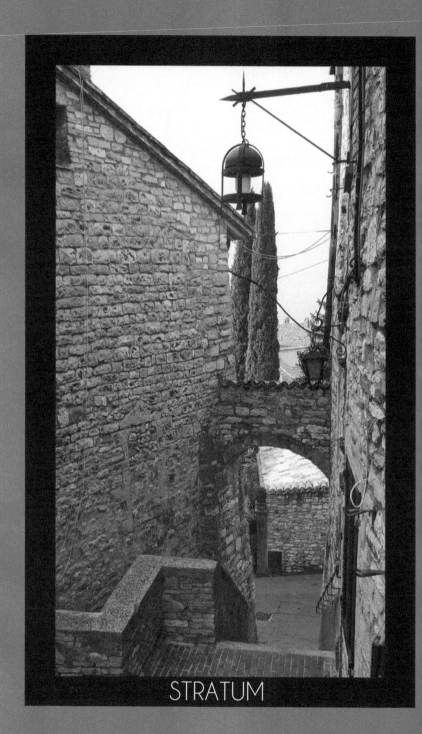

STRATUM

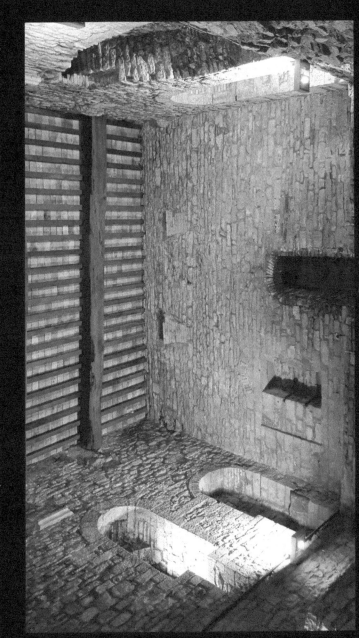

IN THE HOLD

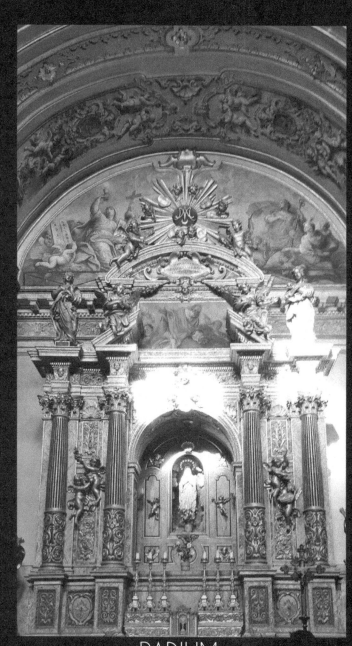

RADIUM

WALKING STAFF

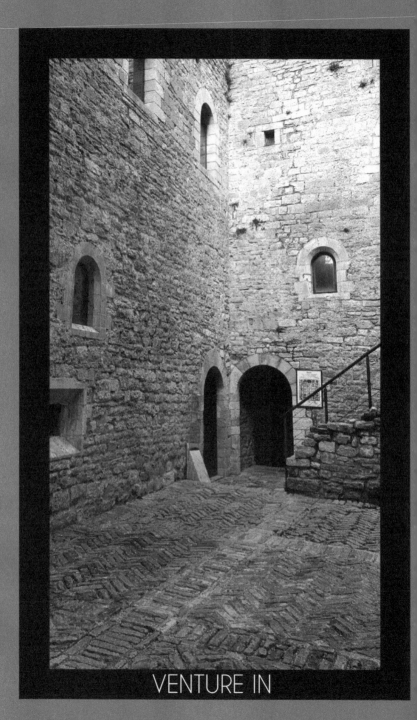

VENTURE IN

CHEEK BY JOWL

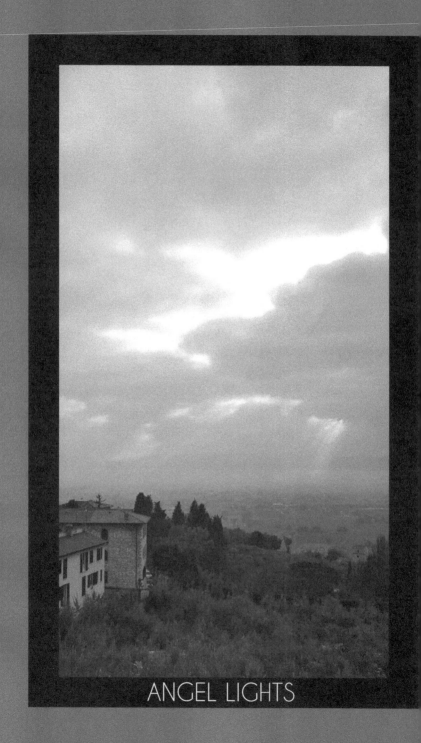

ANGEL LIGHTS

About the Author

Laine Cunningham leads readers around the world. *The Family Made of Dust* is set in the Australian Outback, while *Reparation* is a novel of the American Great Plains. Her travel memoir *Woman Alone* appeals to fans of *Wild* and *Eat Pray Love*.

Novels by
Laine Cunningham

The Family Made of Dust

Beloved

Reparation

Other Books by
Laine Cunningham

Woman Alone: A Six-Month Journey
Through the Australian Outback

On the Wallaby Track

Seven Sisters: Spiritual Messages from Aboriginal Australia

Writing While Female or Black or Gay

The Zen of Travel
The Zen of Gardening
Zen in the Stable
The Zen of Chocolate
The Zen of Dogs

Lightning Source UK Ltd.
Milton Keynes UK
UKHW051956290322
400783UK00006B/226